New York Rising

NEw YORK AND THE FOUNDING OF THE UNITED STATES

SCALA

NEW-YORK
HISTORICAL
SOCIETY
MUSEUM & LIBRARY

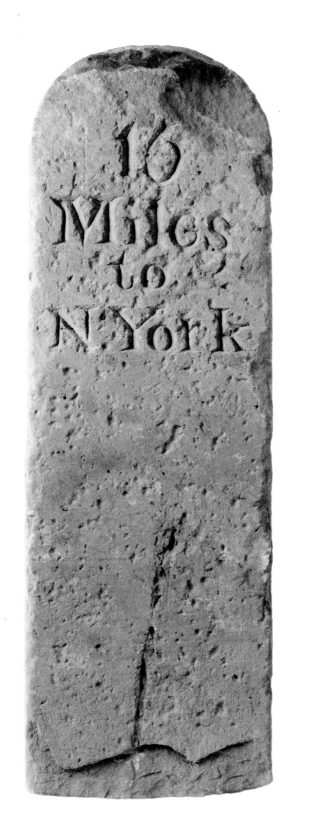

Foreword

Founded in 1804 by eleven visionary men who had lived through the American Revolution, the New-York Historical Society is New York City's oldest museum. This group understood that the material evidence of this important history needed to be preserved for future generations. An astonishing collection of more than ten million documents, works of art, objects, books, maps, and photographs, our museum and library treasures, which range from the seventeenth century through the present, tell stories that are as American as they are New York: stories of diversity, ambition, toleration, and commerce.

A three-year renovation of the galleries and halls of our landmark building on Central Park West has given us a special opportunity to tell these stories. In particular, the installations and media of the new Robert H. and Clarice Smith New York Gallery of American History offer the palpable presence of history to audiences of all ages. Here we have mined our remarkable collection, placing many more objects on display than ever before. Our showstopping, forty-five-foot gallery wall, which is hung salon-style and augmented with floor cases and freestanding sculptures, offers a particularly important perspective: the incredible and fascinating story of the rise of New York in the late eighteenth and early nineteenth centuries. To more vividly tell this story—especially to new audiences—*New York Rising* harnesses new technologies and their ability to enhance the museum experience and provide almost instantaneous information.

This has meant a tremendous amount of research. Thousands of pages of historical investigation—real detective work in many cases—lie behind each object, document, and boldface word on-screen. For this, and for the curatorial brilliance of the installation, we are grateful to our colleague Dr. Valerie Paley, and to her research team. But *New York Rising* could never have been more than a notion without the support of friends. We owe a deep debt of gratitude to the Smith Family, Bloomberg, Con Edison, and Bank of America.

Louise Mirrer, PhD
President and CEO
New-York Historical Society

Introduction

Everyone likes a good story—particularly one with a satisfying ending. Thus, it is no surprise that in the United States a grand historical narrative of the American Revolutionary War has prevailed. In broad strokes, it conveys the triumph of social and political forces for independence battling insurmountable odds against the British Empire. It is the tale of great men moved by republican values and controversial ideologies, culminating in the birth of a unique and powerful new nation.

Accordingly, students and readers of history alike have come to know the brave eighteenth-century Bostonians who put their lives and their city on the line in response to intolerable British taxation and control. We recognize their revolutionary brethren in nearby Lexington and Concord who witnessed the "shot heard 'round the world," commencing the war in April 1775. We lionize the brilliant colonial leaders who convened in Philadelphia in 1775 and hammered out the Declaration of Independence within a year. Through imagery we are familiar with the legend of Washington's stealth attack on December 25, 1776, when he and his troops boarded flimsy boats to cross the Delaware River and surprise the enemy near Trenton, New Jersey. And we recall that in 1781, following a siege in Yorktown, Virginia, British General Cornwallis surrendered to Washington, effectively ending the war.

But what do we remember of New York City's role in the proceedings? While it may have been home to founding fathers Alexander Hamilton, Gouverneur Morris, John Jay, and Robert R. Livingston, the city nevertheless was a Loyalist stronghold. It also was the site of Washington's most resounding defeat and the largest conflict of the war, the Battle of Brooklyn, in August 1776. Soon thereafter, the British seized the city and occupied it as their base of North American operations. It was in ruins by November 1783, when the British marched out on Evacuation Day. Thus, the history of the Revolutionary period in New York understandably has been overshadowed by the account of the subsequent ascent of the metropolis as a world capital.

Yet the Federal period was an important time in which the histories of the United States and New York City were intricately and fundamentally connected. The New-York Historical Society's installation *New York Rising* reveals the complexities of this often-neglected story. New York, after all, was the first national capital. New York was where the Bill of Rights was drafted; it was where George Washington was inaugurated president; and it was where the Supreme Court first met. By 1800, it was the largest city in the United States and Wall Street—a thoroughfare in lower Manhattan—was emerging as America's financial center. The very outlines of the city we recognize today as New York—with all its diversity, contentiousness, and innovation—were firmly coming into being. Indeed, out of the ashes of the British occupation arose an extraordinary and dominant American city.

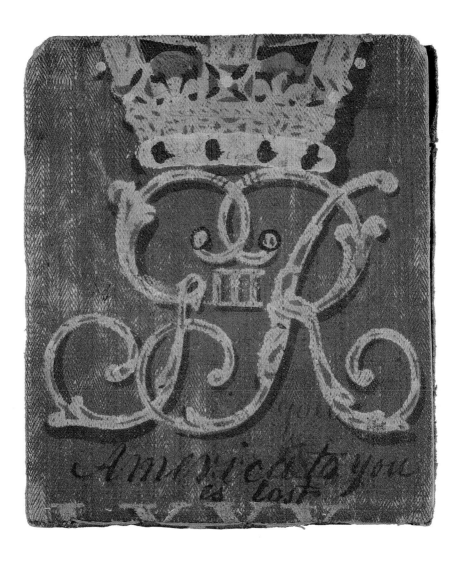

Even so, the founders of the New-York Historical Society recognized that in a milieu defined by state and local identities, a greater, larger whole might prevail in the United States. As these men contemplated the passing of the Revolutionary era to which they had borne witness, they collected the important ephemeral documents of the time, even as they contributed to forging and preserving the notion of an American civilization itself. The Historical Society is their legacy, and one that we are proud to explore in this exhibition.

Valerie Paley, PhD
Historian for Special Projects and Curator
Robert H. and Clarice Smith New York Gallery of American History

New York Rising

On April 30, 1789, at Federal Hall on Wall Street, George Washington was inaugurated the first president of the United States. The event was just one of a series of landmark moments in early American history to which New York served as both host and witness. After suffering seven years of British occupation, the city emerged from the Revolution riding a wave of confidence in the prospects of the new American nation. As the first capital of the United States, New York was the epicenter of intellectual debate, and citizens of every description flocked to the city. The port surged with activity. Coffeehouses were abuzz with the latest commercial news and political maneuvering, and the streets were electric with possibility, ambition, and talent. Even as it rebuilt an infrastructure that had been reduced to rubble and restored a populace decimated by war, the city quickly developed into the leading center of maritime commerce, information, and an expanding political culture.

In this climate, members of the Revolutionary generation founded an organization that would "collect and preserve whatever may relate" to the history of the United States, and of New York in

particular. The aims of the New-York Historical Society were national, its inspiration local. Its collection would tell the story of the city's role in the new nation and of its founding fathers; it also would come to celebrate American Indian leaders, abolitionists, pioneering women, and a city of free New Yorkers, who together forged an American civilization and its most exemplary metropolis.

This volume—and the exhibition it accompanies—draws from the collections of the city's oldest museum to illuminate an era in which the histories of New York City and the United States unfolded simultaneously. Arranged in the manner of the "salon style" display popular in the nineteenth century, the exhibit itself is enhanced by twenty-first-century technology that enables visitors to look beyond the iconic images and events to see the complex—and sometimes surprising—contexts in which they occurred.

Revolution

For most of the Revolutionary War, New York was occupied by the British Army and the Royal Navy, and the city served as their North American headquarters. Yet prior to becoming a Loyalist stronghold, New York was a hotbed of Revolutionary agitation and dissent. From the toppling of the statue of King George III at Bowling Green to the treachery of Benedict Arnold, the bravery of Nathan Hale, the misery of the prison ships, or the creation of the Society of the Cincinnati, New York was the setting for some of the most heroic moments of the Revolutionary era. Out of chaos and destruction rose a powerful and vibrant city.

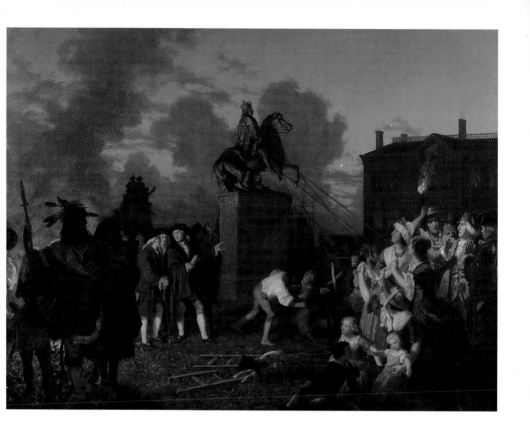

Johannes Adam Simon Oertel (1823–1909)
***Pulling Down the Statue of King George III,
New York City,*** 1852–53
Oil on canvas | Gift of Samuel Verplanck Hoffman, 1925.6

Shortly after emigrating to America from his native
Germany, Johannes Oertel painted the destruction
of the statue of King George III at Bowling Green
on July 9, 1776. He may have been commenting on
the popular uprising that swept the German states
in 1848 (which was ultimately suppressed) when
he depicted the moment in which a symbol of the
monarchy was destroyed as the spark that ignited
a successful democratic revolution.

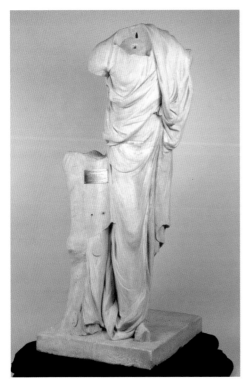
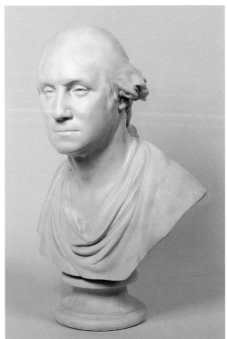

Joseph Wilton (1722–1803)
William Pitt, the Elder, First Earl of Chatham (1708–1778), ca. 1770
Marble | Gift of Mr. Simon F. Mackie, 1864.5

In 1766, New York's General Assembly commissioned British artist Joseph Wilton to create this sculpture of British Minister William Pitt, along with a grand statue of King George III. Despite the British Empire's dire need of American tax revenue, Pitt was one of the most outspoken critics of the Stamp Act in Parliament. Pitt's likeness stood at the intersection of Wall and William Streets for a few short years, enduring disfigurement at the hands of British soldiers during the occupation of New York City.

Jean-Antoine Houdon (1741–1828)
George Washington (1732–1799), ca. 1785–1828
Painted plaster | Gift of Dr. David Hosack, 1832.4

The renowned French sculptor Jean-Antoine Houdon came to the United States to execute a sculpture of Washington, commissioned by the Virginia Assembly. In order to create this realistic portrait, Houdon first created a life mask, made by applying plaster to the subject's face over a layer of grease. Houdon used the life mask to make four different plaster busts of Washington. In this version, Washington is shown wearing a toga-like garment, recalling the dress of ancient Roman leaders.

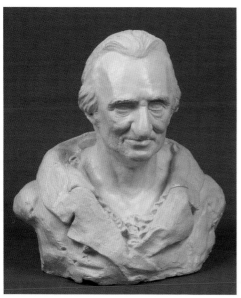 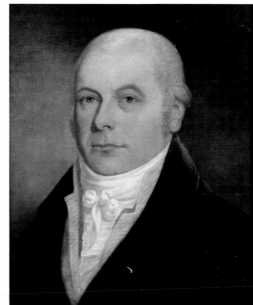

John Wesley Jarvis (1780–1840)
Thomas Paine (1737–1809), 1809
Painted plaster | Gift of the artist, 1817.12

Thomas Paine, the author of seminal pamphlets *Common Sense* (1776) and *The American Crisis* (1776–1783), fell from public favor as a consequence both of his attacks on organized religion—particularly in *The Age of Reason*, which he wrote while imprisoned in France—and his public defamation of his former friend George Washington. Paine spent the end of his life as an impoverished boarder in John Wesley Jarvis's home. This bust is the only work of sculpture attributed to Jarvis, who was known as a portraitist, and who modeled it after a cast he took of Paine's face on his deathbed.

Charles Willson Peale (1741–1827)
Richard Varick (1753–1831), 1806
Oil on linen | Museum purchase, 1982.15

Richard Varick, the mayor of New York City from 1789 to 1801, and Charles Willson Peale, one of the best-known artists of the period, shared an interest in upholding the legacy of the Revolution. As George Washington's private secretary during the war, Varick was instrumental in preserving the general's correspondence and even his camp bed, which, along with Varick's papers, are now in the collection of the New-York Historical Society.

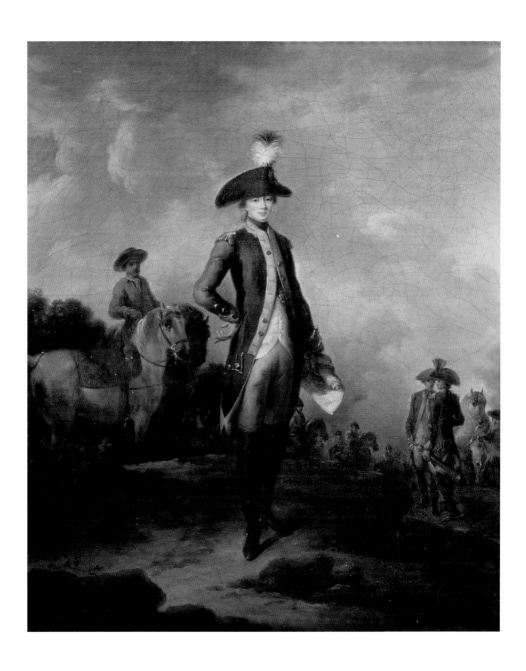

Francesco Giuseppe Casanova (1727–1802)
Marquis de Lafayette (1757–1834), ca. 1781–85
Oil on canvas | Gift of Forsyth Wickes, 1939.9

Francesco Giuseppe Casanova (brother of the amorous adventurer Giovanni Giacomo
Casanova) painted the Marquis de Lafayette in the aftermath of the battle of Yorktown,
during which the British were forced to surrender to American and French forces.
Casanova, who had trained in Italy and specialized in idealized military scenes, was
well-suited to portray Lafayette as a victorious young hero.

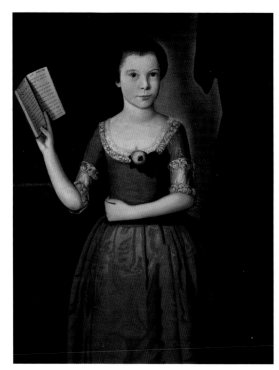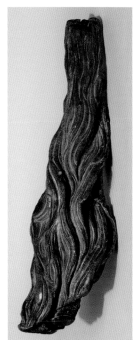

John Durand (1731–1805)

Jane Beekman (1760–1841), 1767

Oil on canvas | Gift of the Beekman Family Association, 1962.72

Jane Beekman was the oldest daughter of the wealthy merchant James Beekman and his wife, Jane Keteltas Beekman. This portrait depicts Jane holding a book by the eminent Dutch humanist Erasmus. This symbol of classical education was an unusual choice at a time when portraits of young women tended to focus on beauty, patience, and purity, rather than intellect. After the war, prominent families like the Beekmans led the way in translating Revolutionary ideals into educational opportunities for women.

Joseph Wilton (1722–1803)

Fragment of an equestrian statue of King George III (tail), 1770–76

Lead | Museum purchase, 1878.6

British sculptor Joseph Wilton's statue of King George III was modeled after a second-century statue of the Roman Emperor Marcus Aurelius. Installed in 1770 at Bowling Green, it was the first equestrian statue erected in the American colonies. In July 1776, after hearing the Declaration of Independence read aloud, a crowd tore down the statue. King George's head was fixed on a spike, as would have been done to an executed criminal. British Loyalists later recaptured the head and sent it to England as evidence of the colonists' ingratitude and perfidy. Legend has it that Loyalists stole this tail fragment when the statue passed through Wilton, Connecticut, on its way to Litchfield to be melted into bullets. It was discovered almost a hundred years later in a swamp and purchased by the New-York Historical Society.

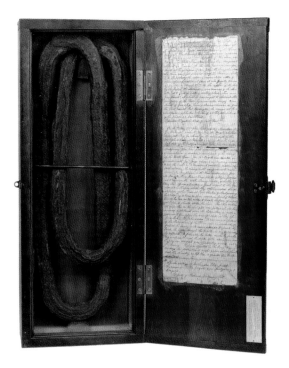

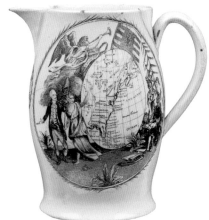

Unidentified maker
Links (two) of the Fort Montgomery Chain in box, 1776–77
Iron, walnut, brass | Gift of Mrs. Louis T. Hoyt, in memory of her husband, Richard Montgomery Pell, 1928.98

These links were part of a chain that was stretched across the Hudson River in 1776 from Fort Montgomery, near West Point, to the peak opposite (known as Anthony's Nose). It was intended to keep British ships from navigating the waterway. Many of the links were repurposed from a chain used to block the River Sorel, near Lake Champlain, during the summer of 1776. Additional links were forged by Poughkeepsie ironworkers, using iron from Livingston Manor. However, production slowed when the Secret Committee (which had commissioned the chain) proved incapable of compensating ironmaster Robert Livingston. The chain lasted only a year, and was destroyed and dismantled by the British in October 1777.

Unidentified English maker
Pitcher, "Success to America," 1785–1800
Earthenware | Gift of Mrs. Robert C. Taylor, 1945.374

This earthenware pitcher, made in England, is decorated with several transfer-printed images that relate to American independence, including a liberty cap on a pole, the figures of George Washington and Liberty, and a banner proclaiming "Independence." Before and (especially) after the Revolution, manufacturers in the ceramics centers of Liverpool and Staffordshire shipped large quantities of patriotic goods across the Atlantic Ocean to ports in New York and elsewhere. Manufacturers in the United States were not yet capable of competing with either the output or quality of British goods, and until American industry gained strength in the 1830s and 1840s, Americans received most of their consumer goods from England.

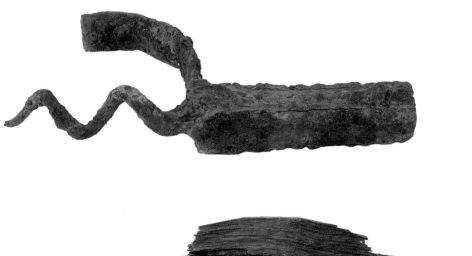

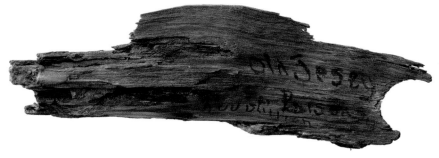

Unidentified maker
Corkscrew fragment excavated at a British Revolutionary War camp, 1760–75
Iron | Gift of the Washington Headquarters Association, Daughters of the American Revolution, 1947 INV.5924.412

Before the formation of the New-York Historical Society Field Exploration Committee in 1918, Reginald Bolton, William Calver, and others excavated the site of a British camp at the Dyckman farm (located at 204th Street between Seaman and Payson Avenues, in Inwood). This corkscrew was discovered on the site. It was, perhaps, not an unusual find, as rum usually was issued to all soldiers as part of their rations; wine was often the personal property of officers.

Unidentified maker
Piece of wood from British prison ship *Jersey*, 1750–80
Wood | Gift of Elizabeth Stevens, 1973.52

By 1776, the British warship *Jersey* was decades old and in poor condition. During the Revolutionary War, it was repurposed to serve as a prison for American soldiers, and its unhygienic conditions led to the deaths of more Americans in captivity than in all of the battles and campaigns of the Revolution. Under the corrupt management of British Commissary Joshua Loring and Provost Marshal William Cunningham, prisoners were regularly beaten, starved, deprived of water, and restricted to dark, cramped quarters below deck. Many saw no daylight for several years. Loring is even known to have auctioned off food intended for the ships at great personal profit, leaving prisoners with inedible provisions.

Johann Hamer (active second half of eighteenth century)
Tobacco box, 1770–90
Copper, brass | Purchased from Elie Nadelman, 1937.1344

The portraits of George II and George III on the lid of this German-made tobacco box suggest that it was likely made for the English market. Tobacco, a product of the Americas, was for centuries a luxury product in Europe. As tobacco became increasingly more accessible and less expensive by the eighteenth century, European tobacco boxes were produced in larger sizes, like this example.

Barnardus Swartwout (1761–1824)
Orderly Book, 2nd New York Regiment, 1781
BV War Orderly Books

General George Washington mandated orderly books—journals in which official orders, daily routines, and resolutions were both recorded and circulated—for all companies in the Continental Army. Barnardus Swartwout was only seventeen years old in September 1778, when he was commissioned as an ensign in the 2nd New York Regiment by Philip Van Cortlandt. This orderly book is adorned with a British flag, and the inside front cover reads, "Captured Lord Cornwallis & the cover of this book." Cornwallis surrendered on October 19, 1781, at the decisive battle of Yorktown.

United States Continental Congress

"In Congress, July 4, 1776. A declaration by the representatives of the United States of America, in general Congress assembled." [Declaration of Independence]

Broadside | New York: Printed by Hugh Gaine SY1776 no. 5

This printing of the Declaration of Independence was circulated by Hugh Gaine, who in 1752 had established the *New York Mercury*. Gaine's revolutionary zeal did not survive the war, however, and after the British Army occupied New York later in 1776, the *Mercury* became a staunch Loyalist newspaper.

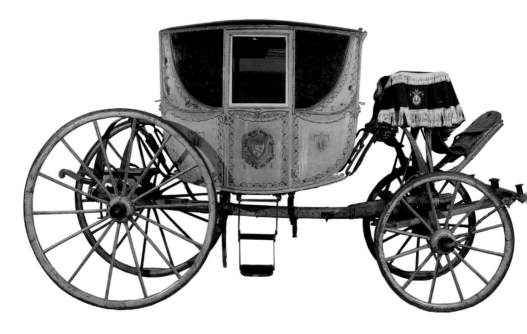

Unidentified maker
Beekman family coach, ca. 1770
Wood, iron, paint | Gift of Gerard Beekman, 1911.25

By the 1750s, James Beekman had amassed a fortune as a dry goods importer, on account of growing consumer demand. While his political beliefs leaned toward the democratic, like many wealthy New Yorkers, he embraced the trappings of aristocracy. After taking control of New York in 1776, British General William Howe used Beekman's abandoned estate as his headquarters. According to his ledgers, Beekman purchased this coach in 1771. Its intricate design and luxurious interior made it one of the finest carriages in New York. It is one of the few eighteenth-century coaches still in existence.

British Tax Stamp for use on parchment, two shilling, sixpence, 1765
Library Currency Collection

In 1765, the British Parliament passed the Stamp Act, legislation taxing paper materials like newspapers, legal documents, and business papers. It required that most printed matter bear a seal or "stamp," like this one, to indicate that the bearer had paid the appropriate levy. As a commercial center of the North American colonies, New York, along with Philadelphia and Boston, relied heavily on such documents. Passage of the act set off months of protest, culminating in the Stamp Act Congress of October 1765, and repeal of the law in March 1766.

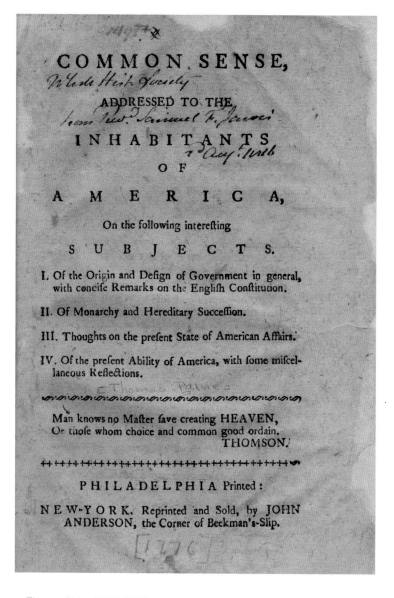

COMMON SENSE,

ADDRESSED TO THE

INHABITANTS

OF

AMERICA,

On the following interesting

SUBJECTS.

I. Of the Origin and Defign of Government in general, with concife Remarks on the Englifh Conftitution.

II. Of Monarchy and Hereditary Succeffion.

III. Thoughts on the prefent State of American Affairs.

IV. Of the prefent Ability of America, with fome mifcellaneous Reflections.

Man knows no Mafter fave creating HEAVEN,
Or thofe whom choice and common good ordain.
THOMSON.

PHILADELPHIA Printed:

NEW-YORK, Reprinted and Sold, by JOHN ANDERSON, the Corner of Beekman's-Slip.

Thomas Paine (1737–1809)

Common Sense

Title page | New York: John Anderson, 1776 Pamph AC1.L8 no.50

Thomas Paine, always a guarded critic of British policies, was inspired by the charged political atmosphere of America. In *Common Sense*, he attacked monarchy and promoted the ideal of a republic that would usher in a new political age. The ideas he expressed were not new, but Paine framed them using strikingly simple and logical rhetoric. *Common Sense* spread like wildfire through American coffeehouses, taverns, and homes and was the most successful American publication of the eighteenth century. It played an indispensible role in convincing average colonists to embrace independence and transformed Paine overnight into a patriot hero.

Marketplace

On May 17, 1792, under a buttonwood tree near Wall Street, twenty-four stockbrokers gathered to sign an agreement that would serve as a precursor to the New York Stock and Exchange Board, the predecessor of the New York Stock Exchange. The brokers would perform their transactions in a second-floor room of the Tontine Coffee House.

At the time, financial and political wrangling often took place in taverns and coffeehouses. At the Tontine, self-made men—both black and white—traded gossip and conducted business. Ship captains came to share commercial news and to register cargo—including the human cargo of enslaved men, women, and children.

The mercantile city also was crowded and unsanitary, and frequent outbreaks of infectious disease not only hastened the growth of the city northward, away from the crowded downtown, but also propelled strides forward in medical research and treatment.

This section explores how New York rebuilt itself after the Revolutionary War to become the most important city in North America.

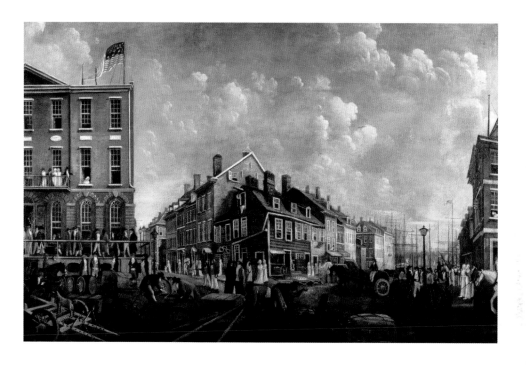

Francis Guy (1760–1820)
Tontine Coffee House, New York City, ca. 1797
Oil on linen, lined to fiberglass | Museum purchase,
Louis Durr Fund, 1907.32

Francis Guy, one of the first artists in the United
States to specialize in landscapes, depicted
the financial crossroads of eighteenth-century
New York in this painting. The Tontine Coffee
House was built at the intersection of Wall and
Water Streets in 1792–93, and quickly became
an important meeting place for merchants and
traders to bargain for cargo arriving on ships at the
East River wharves, visible in the background.

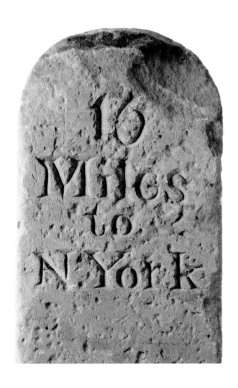

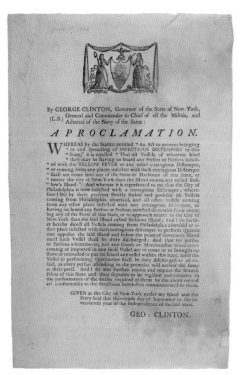

Unidentified maker

Milestone, ca. 1802

Marble | Gift of Mr. Leonard H. Davidow, 1960.80

Milestones were essential tools for navigating the areas around New York in the eighteenth and nineteenth centuries. Placed throughout Manhattan and the Bronx, the mile markers noted the distance to City Hall, in lower Manhattan. This milestone first stood on the New Boston Post Road, in the Bronx, and was later moved a short distance north to just above East 222nd Street.

George Clinton (1739–1812)

"By George Clinton, Governor of the State of New York... A Proclamation. Whereas by the statute entitled 'An act to prevent bringing in and spreading of infectious distempers in this state,' it is enacted...," 1793

Broadside | SY 1793 no. 29

After an outbreak of yellow fever in Philadelphia, George Clinton forbade any ships originating there, or in other infected cities, from entering New York Harbor. Likewise, no goods or people from potentially infected ships were permitted to come ashore. Despite Clinton's measures, New York experienced outbreaks of yellow fever almost annually until 1821.

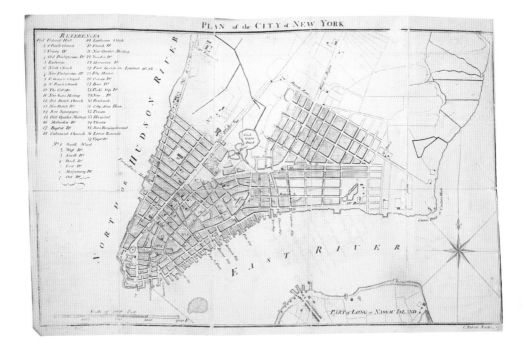

John McComb Jr. (1763–1853)

Plan of the City of New York [i.e., Manhattan North to about Houston Street], 1789

Black ink with hand-coloring on paper | NS9 M29.5.72

In 1789, when this map was drawn, most of New York's roughly thirty-three thousand residents were densely clustered below Chambers Street. To the north, Manhattan was divided into farmland, large estates, and unsettled wilderness. John McComb Jr., who drew this map, was the architect of many notable buildings in New York, including its City Hall, the country house of Alexander Hamilton, and Gracie Mansion, which became the official mayoral residence. The map's key gives pride of place to Federal Hall, where George Washington was inaugurated on April 30, 1789.

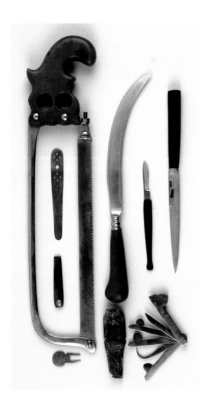

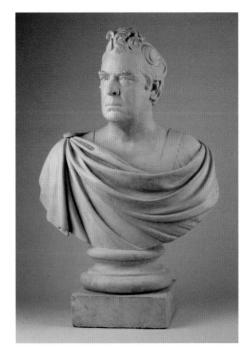

Unidentified maker
Set of surgical instruments, ca. 1776
Wood, metal, horn, tortoiseshell | Gift of Miss Ethelwyn Bradish and Mrs. Mary Bradish Call in memory of their father, Walter Horace Bradish, 1957.262a–k

This set of surgical tools was used during the Revolutionary War by Dr. James Bradish (1752–1818), the surgeon's mate of the 9th Massachusetts Continental Regiment. With tools like these, doctors could perform a range of surgeries from amputations to bloodlettings. Nevertheless, due to unhygienic conditions in the field, many soldiers died of infection and disease.

John Henri Isaac Browere (1798–1834)
David Hosack, M.D. (1769–1835), ca. 1825–30
Painted plaster | Gift of Dr. John W. Francis, 1832.2

A founder of the New-York Historical Society, the eminent physician David Hosack helped professionalize the practice of medicine in the United States and was doctor to such notable figures as Alexander Hamilton, Aaron Burr, Robert Fulton, and Gouverneur Morris. The artist John Browere created this bust from a life mask cast directly from his subject's face. A skilled technician, Browere used his masks to create perfect likenesses of his subjects.

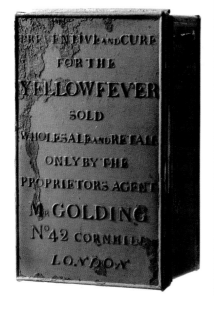

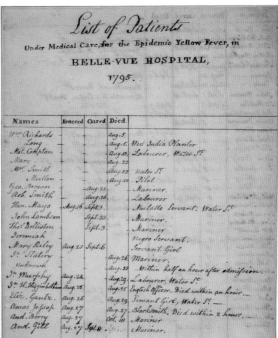

Unidentified maker
Medicine box, 1820–70
Metal | Z.1508

This box originally contained medicine that was supposed to prevent and cure yellow fever, one of the deadliest infectious diseases of the eighteenth and nineteenth centuries. Unfortunately for patients, medicines for yellow fever were useless at best, poisonous at worst. Doctors did not learn how to prevent yellow fever until 1937, and even today there remains no cure.

Dr. Alexander Anderson (1775–1870)
List of patients under medical care in Bellevue Hospital during the yellow fever epidemic, and the disposition of their cases, 1795
Alexander Anderson Papers

Dr. Alexander Anderson kept detailed records of patients sick with yellow fever at Bellevue Hospital. The list includes patients' names, addresses, and occupations, and the date that they were either cured or died of the disease.

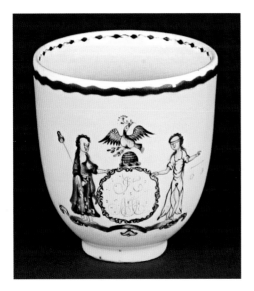 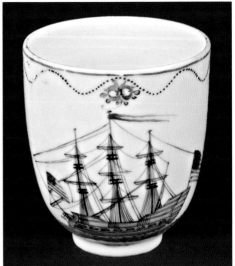

Unidentified Chinese maker
Coffee cup, ca. 1795
Porcelain | Bequest of Mrs. J. Insley Blair. 1952.127

This porcelain coffee cup, made in China for the American market, features a variation
of the seal of New York State, a popular decorative motif on Chinese export porcelain.
The shield, flanked by Liberty and Justice, would have been left blank by manufacturers
so that the porcelain could be personalized by a local gilder with the initials of its
owners, as was done for this cup.

Unidentified Chinese maker
Coffee cup, ca. 1800
Porcelain | Bequest of Mrs. J. Insley Blair. 1952.118f

This cup, also made in China for the American market, is decorated with a three-masted
ship and features two large American flags. Such porcelain pieces allowed the owners
both to display their good taste and wealth and show their allegiance to the newly
independent country.

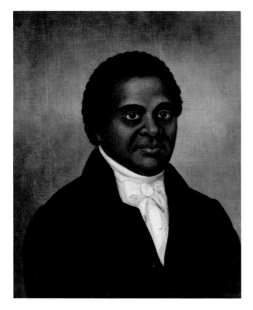 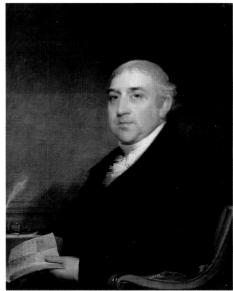

Unidentified artist
Peter Williams (1750–1823), ca. 1810–15
Oil on canvas | X.173

In 1783, the John Street Methodist Church bought a slave named Peter Williams for forty pounds sterling. Williams worked as the church sexton and eventually earned his freedom, becoming a prominent member of New York's free black community. A successful tobacconist, Williams also was a spiritual leader and philanthropist. He was among the founders of the Zion Chapel and the New York African Society for Mutual Relief. This portrait originally belonged to Williams and later to his daughter, before its acquisition by the New-York Historical Society.

Gilbert Stuart (1755–1828)
Augustine Hicks Lawrence (1770–1828), ca. 1812–15
Oil on canvas | Bequest of Mrs. Eloise Lawrence (Breese) Norrie, 1921.1

Following the panic of 1792, Augustine Lawrence, along with twenty-three other traders and business partners, signed the Buttonwood Agreement, whose guidelines would be incorporated into the New York Stock Exchange, founded in 1817. Lawrence traveled to Boston in the early 1810s to have his likeness painted by the prolific and acclaimed portrait artist Gilbert Stuart, who also painted George Washington and Robert Livingston, among others.

"Subscribers of shares of the Tontine Coffee-House," 1794–95

BV Tontine

The Tontine Coffee House got its name from the investment scheme used to finance it. A tontine was part lottery, part life insurance policy. Subscribers invested a certain amount of money into the coffeehouse and took an even share in any profits. In this particular case, a shareholder could choose a nominee, often a young child, whose death would dictate the termination of the investment. When a nominee died, the investor no longer received dividends, and the remaining members increased their profits. This document is from a list of shareholders and their nominees.

Chamber of Commerce to the Attorney General of the State of New York

Invitation to dinner at the Tontine Coffee House in honor of Alexander Hamilton, February 23, 1795

Hall Park McCullough Collection

This invitation, sent to New York State Attorney General Nathaniel Lawrence, invites guests to attend a dinner at the Tontine Coffee House and join "in testimony of the their Esteem for Alexander Hamilton." When this letter was written, Hamilton had just returned to New York after serving as the first Secretary of the Treasury of the United States.

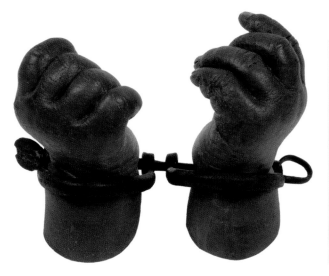
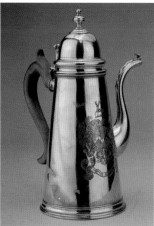

Unidentified maker

Slave shackles intended for a child, ca. 1800

Metal | Gilder Lehrman Collection (GLC06151)

Iron shackles like these were used to control prisoners as early as the sixteenth century in Europe. Pairs like these were likely used during the transport of slaves across the Atlantic Ocean during the Middle Passage. These shackles are notable for their diminutive size, which indicates that they were probably used to restrain a very small child. It is likely that young children were chained up to prevent their parents from attempting escape.

Peter Van Dyck (1684–1750)

Coffeepot, ca. 1730

Silver, wood | Gift of Mr. & Mrs. Alexander O. Vietor, 1972.26

Tea and coffee were fashionable drinks in eighteenth-century New York, and elite New Yorkers purchased expensive silver beverage services for them. Silver objects like this one were at once status symbols, useful objects, and a form of currency during a time when banks did not exist in New York. This fine coffeepot is marked by Peter Van Dyck, the accomplished New York City silversmith. Although it was made in the United States, its form recalls examples made in London during the early eighteenth century.

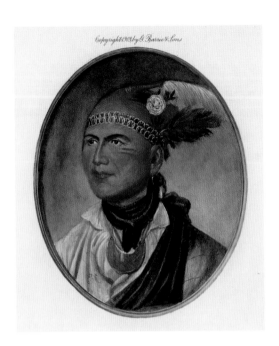

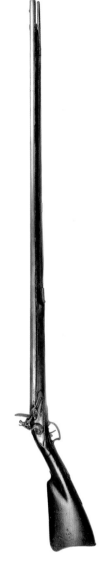

Unidentified artist, after Charles Willson Peale (1741–1827)
Thayendanegea, Joseph Brant, 1903
Hand-colored lithograph | Published by G. Barrie & Sons, Philadelphia PR 052

Joseph Brant, a Mohawk chief, served as a cultural emissary to the American, British, French, and Iroquois nations. On the eve of the American Revolution, Brant visited England to confer with King George III about Mohawk concerns, and, after the war, Brant became a key negotiator between Iroquois tribes and the American government. Like the Seneca leader Cornplanter, Brant employed many strategies to preserve tribal lands. However, he was a particularly strong advocate of using pan-tribal unity to stem the rising tide of westward-bound American settlers.

Unidentified maker
Flintlock fowling piece, 1750–70
Wood, iron, brass, flint | Gift of Howland Pell, 1927.99

According to the donor, this fowling piece, a kind of flintlock musket, may have belonged to Joseph Brant, Mohawk chief and political and cultural ambassador during the Revolutionary and post-Revolutionary eras. The brass bayonet lug visible below the muzzle of this gun indicates that it was equipped for military use. Well-educated and well-traveled, Brant socialized with New Yorkers like Aaron Burr, and moved adeptly between American Indian and white cultures.

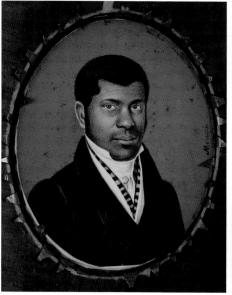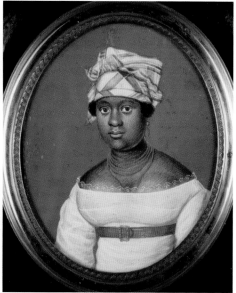

Anthony Meucci (active 1818–1827)
Pierre Toussaint (ca. 1781–1853), ca. 1825
Watercolor on ivory | Gift of Miss Georgina Schuyler, 1920.4

Pierre Toussaint was born into slavery in Haiti before immigrating to New York with his owners, the wealthy Bérard family. This portrait miniature depicts him after he had risen to a position of prominence as one of New York City's most successful hairdressers. His success allowed him to accumulate a fortune, which he used to support charitable works, notably the orphanage of the Catholic nun, New Yorker Mother Elizabeth Ann Seton. In 1996, the Vatican declared Toussaint venerable—an important step toward becoming a saint, like Seton. If canonized, Toussaint would be the Catholic Church's first black American saint.

Anthony Meucci (active 1818–1827)
Mrs. Pierre Toussaint (Juliette Noel, ca. 1786–1851), ca. 1825
Watercolor on ivory | Gift of Miss Georgina Schuyler, 1920.5

Toussaint purchased the freedom of his fiancée, Juliette Noel, before his own. The couple married in 1811 and together pursued important philanthropic endeavors. In this miniature, Juliette wears coral jewelry and a white dress decorated with fine lace, suggesting her family's financial success. Her hair is wrapped in a madras handkerchief, a popular hair accessory among French women.

Capital

On April 30, 1789, George Washington was inaugurated president of the United States on the balcony of Federal Hall, in lower Manhattan. Though remarkable in itself, the inauguration was only one of a series of legislative and diplomatic milestones that occurred between 1785 and 1790, when New York served as the national capital.

For Washington and his contemporaries, the city was a laboratory in which the ideals that had inspired the Revolution could be tested. It was here that Washington and others began consciously crafting an American identity; that venues like Fraunces Tavern became the first offices for government officials like John Jay and Alexander Hamilton; and that an American Indian named Cornplanter protested against white western expansion.

From tastemaking to the Bill of Rights, it is this era in which the histories of the city and the new nation converged for the first time.

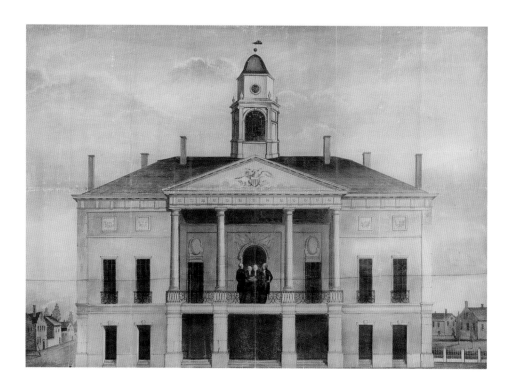

Giuseppe Guidicini (1812–1868)
President Washington Taking the Oath, Federal Hall, 1789, 1839

Oil on fine linen | Commissioned by the New-York Historical Society, X.269

To commemorate the fiftieth anniversary of George Washington's inauguration, the New-York Historical Society paid Italian scene painter Giuseppe Guidicini twenty dollars to create a painted "transparency" of the event. Upon a thin sheet of oil-treated linen, Guidicini depicted Washington taking the inaugural oath on the balcony of old Federal Hall. A candle burning behind the work illuminated the scene to "brilliant effect." During a dinner at the City Hotel to celebrate its acquisition, the painting was hung behind the chair of Peter Gerard Stuyvesant (1778–1847), then president of the New-York Historical Society.

Unidentified maker

George Washington inaugural armchair,
1788–89

Mahogany, pine, yellow poplar | Gift of Edmund B.
Southwick, 1916.7

George Washington sat in this Federal-style
mahogany armchair during his inauguration
at Federal Hall in 1789. The chair was used
in two subsequent presidential inaugurations,
those of Ulysses S. Grant in 1873, and James A.
Garfield in 1881.

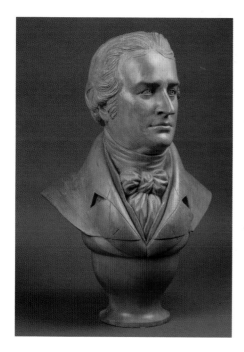
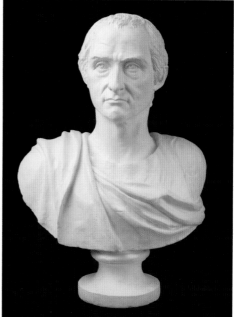

Jeremiah Dodge (1781–1860)
Chancellor Robert R. Livingston (1746–1813), ca. 1816
Painted pine with plaster | Museum purchase, Abbott-Lenox Fund, 1959.53

Robert Livingston, as Chancellor of the State of New York, administered the oath of office to George Washington as the first president of the United States. Early in their careers, Livingston and fellow "founding father" John Jay were college classmates, law partners, patriots, and close friends. But Livingston came to resent Jay's many political appointments, and in 1789 abandoned Jay's Federalist faction in favor of Jeffersonian Republicans, with whom he believed his political ambitions would be realized. The two men ran against each other in New York's 1798 gubernatorial race. Jay won. The two most likely never spoke to each other again.

Giuseppe Ceracchi (1751–1801)
John Jay (1745–1829), 1792
Painted plaster | X.52

As a revolutionary, New Yorker John Jay was a key architect in the shaping of America. He grew up and came of age with other affluent future patriots, including his friend Robert Livingston. Jay coauthored with Alexander Hamilton and James Madison the influential *Federalist Papers*, a series of essays endorsing the not-yet-ratified US Constitution. He went on to serve as a foreign diplomat, as the first Chief Justice of the US Supreme Court, as Secretary of Foreign Affairs, and as Governor of New York State.

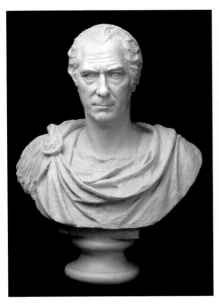

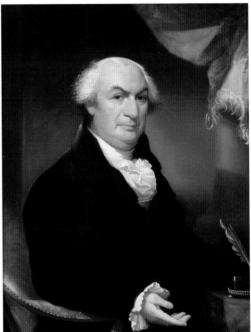

Giuseppe Ceracchi (1751–1801)
George Clinton (1739–1812), 1792

Painted terracotta | X.42

Born into a middle-class family, George Clinton relied on his intelligence and personal
connections to become the most powerful New York politician during the Federal Era.
He served as Brigadier-General of the Revolutionary militia and then later became the
first governor of New York. He served seven terms in that post. Although an outspoken
opponent of the US Constitution, he was nevertheless a gracious host for George
Washington's inauguration.

Ezra Ames (1768–1836)
Gouverneur Morris (1752–1816), ca. 1815

Oil on linen | Gift of Stephen Van Rensselaer, 1817.1

With the insights gleaned from being the youngest son of a wealthy New Yorker, as well
as his political experiences during the American Revolution, Gouverneur Morris had
a strong foundation for his career as a statesman, financier, and diplomat. A prolific
speaker and writer, Morris helped determine the language and structure of the American
Constitution and even wrote its iconic preamble. In his later years, Morris contributed
to many civic organizations, including the New-York Historical Society.

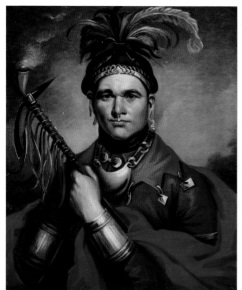
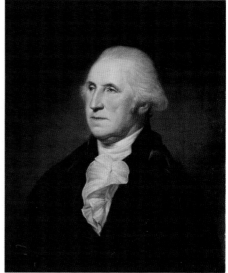

F. Bartoli
Ki On Twog Ky (also known as Cornplanter) (1732/40–1836), 1796
Oil on canvas | Gift of Thomas Jefferson Bryan, 1867.314

Born to an American Indian mother and a Dutch American father, Seneca Chief
Cornplanter spent much of his life as a mediator between Indian and white cultures.
F. Bartoli painted Cornplanter adorned with items that mark him as a person of
importance and an ambassador between both cultures. His red cloak and silver jewelry
were gifts presented by the Confederation Congress in 1786, while his feathered
headpiece, tomahawk pipe, and piercings reflect a European perspective on American
Indian aesthetic traditions.

Charles Willson Peale (1741–1827)
George Washington (1732–1799), 1795
Oil on canvas | Gift of Thomas Jefferson Bryan, 1867.299

Charles Willson Peale painted several full-size and miniature portraits of George
Washington at different times in his life. This portrait was taken at Peale's Museum
in Philadelphia, during Washington's second term in office (1793–97). It emphasizes
Washington's role as a civilian leader rather than a military hero.

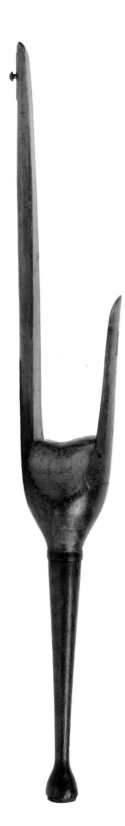

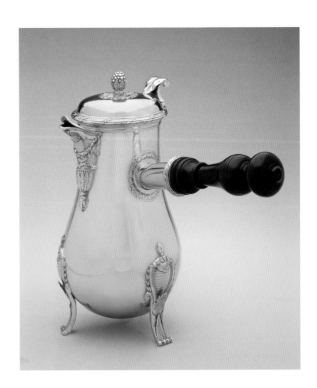

Unidentified maker
Wooden leg of Gouverneur Morris, ca. 1780
Oak, leather, metal | Gift of Mrs. Frederick Menzies,
1954.148

Although he was fitted for a copper prosthetic
leg in Paris, Morris preferred to wear pegged
wooden limbs like this one after losing his
left leg at the age of twenty-eight in a carriage
accident. Apocryphal stories about the
leg emerged almost immediately after the
accident: it was widely rumored that Morris
lost his limb while fleeing from a jealous
husband who caught Morris with his wife.
Later, Morris used the leg to appease an angry
mob in Paris that swarmed his carriage,
decrying him as an aristocrat. Morris
removed his wooden leg, waved it outside the
carriage, and said to the crowd: "An aristocrat!
Yes, truly, who lost his leg in the cause of
American liberty." The mob, then mollified,
cheered Morris as a hero.

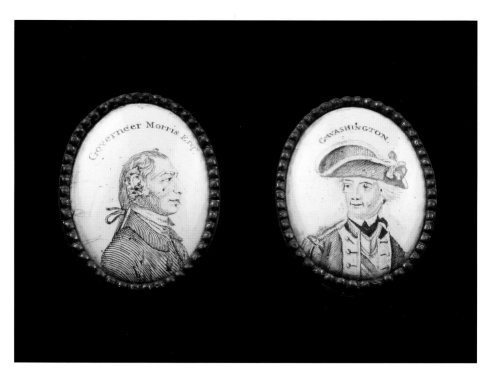

Jacques-Nicolas Roettiers (1736–ca. 1788)
Coffeepot, 1775–76
Silver | Gift of Mr. Goodhue Livingston, 1951.284

Jacques-Nicolas Roettiers was a fourth-generation engraver and silversmith whose family had designed coins, medals, and elegant tableware for several European courts. This coffeepot, a high-status object, was owned by Robert R. Livingston (1748–1814), who served as US minister to France from 1801 to 1804. It may have been purchased in Paris by Gouverneur Morris during the French Revolution. According to letters exchanged by the two men, Morris sold the coffeepot to Livingston in 1801.

Unidentified English maker
Mirror knobs (pair), ca. 1800
Metal, enamel | Gift of Mrs. J. Insley Blair, 1941.933ab

Battersea mirror knobs, named after their place of origin in London, were used in pairs to support a mirror at a tilted angle on a wall. These examples feature portraits of Gouverneur Morris and George Washington. This enamel pair served not only as decoration but also commercialized the images of and paid tribute to two popular Founding Fathers.

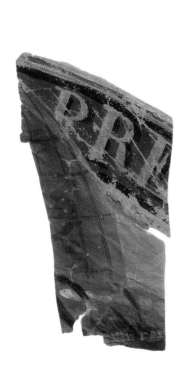

Unidentified maker

Fragment of flag flown during inauguration of George Washington, 1789

Silk, paint | Gift of Dr. John E. Stillwell, 1925.125

This small fragment is from a flag flown during Washington's 1789 inaugural celebrations. Large crowds participated in the festivities, which included processions, fireworks, and parties. The first three letters of the word "PRESIDENT" are still legible on this section of what would have been a large painted banner.

"An Ordinance for the Government of the Territory of the United States, North-West of the River Ohio," April 23, 1784

United States Collection

This is an early draft of what, after the Declaration of Independence, became arguably the most important bill passed by the Congress of the Confederation. As the new nation moved from a collection of colonies to a federated nation-state, the Congress questioned how to expand west across the continent. On July 13, 1787, the Northwest Ordinance created the Northwest Territory in what is now the upper Midwest. This legislation established the parameters of American expansion for the coming decade. The bill banned the existence of slavery in the territory—meaning that each new state from this region that entered the nation remained free—potentially destabilizing the delicate balance of power established east of the Appalachians between free and slave states.

Amendments to the New Constitution of Government.

That there be a Declaration or Bill of Rights, asserting and securing from Encroachment, the Essential and unalienable Rights of the People, in some such manner as the following. —

1. That all Freemen have certain essential inherent Rights, of which they cannot by any Compact, deprive or divest their Posterity; among which are the Enjoyment of Life and Liberty, with the means of acquiring, possessing and protecting Property, and pursuing and obtaining Happiness and Safety.

2. That all Power is naturally vested in, and consequently derived from the People; that Magistrates therefore are their Trustees and Agents, and at all Times amenable to them.

3. That Government ought to be instituted for the Common Benefit, Protection and Security of the People; and that whenever any Government shall be found inadequate or contrary to these purposes, a Majority of the Community hath an indubitable unalienable

and

Bill of Rights, 1789

Lamb Papers

New York Governor George Clinton was only one of many outspoken opponents of the US Constitution. Patrick Henry, George Mason, and other well-known patriots refused to endorse it without a clearer statement of personal liberty and right to property. Recognizing an avenue for compromise, James Madison, an outspoken Federalist and an architect of the new Constitution, drafted the first ten amendments now known as the Bill of Rights, which was adopted in New York by the 1st Congress on September 25, 1789.

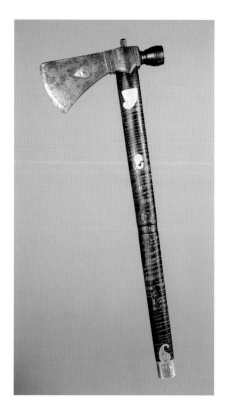

John Jay (1745–1829)

Draft of Treaty with England agreed to by John Jay, special envoy, concluded at London, November 19, 1794

John Jay Papers | Gift of William Jay, 1847

Jay's Treaty helped repair the nation's relationship with Great Britain a decade after the Revolutionary War ended. The agreement, backed by Alexander Hamilton, was ultimately divisive in the United States and helped entrench a two-party political system. The Jeffersonians, who opposed the treaty, battled the Federalists in elections for the next three decades.

Unidentified maker

Pipe tomahawk, 1790–1820

Steel, silver | Gift of Dr. Samuel W. Francis, 1862.1

This pipe tomahawk once belonged to the prominent Seneca Chief Red Jacket, or Sagoyewatha (ca. 1750–1830). It was a symbol of diplomacy, reportedly given to Red Jacket by President George Washington. A leader of his people and a great orator, Red Jacket advocated friendship and coexistence with white culture, but asserted the independence and ownership rights of American Indians.

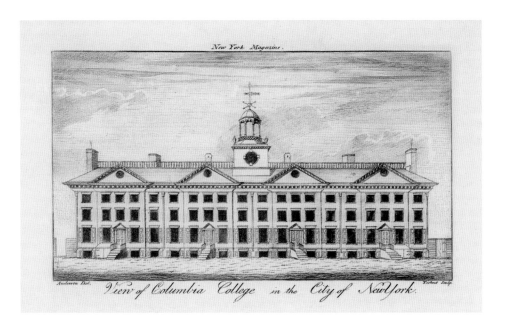

Cornelius Tiebout (1777–1832), after J. Anderson
***View of Columbia College in the City of New York**, 1790*
Line engraving | Published in *New York Magazine* | PR 020

King's College, founded by royal charter of King George II in 1754, was the first institution of higher learning in the State of New York. Although other colonial colleges—including Harvard and Yale—served primarily as training schools for Christian clergymen, King's College students received an education designed to "enlarge the Mind, improve the Understanding, polish the whole Man, and qualify them to support the brightest Characters in all the elevated stations in life." During the British occupation of New York the college was closed. It reopened in 1784 under a new name: Columbia College. This print depicts the college's first building, built in 1760, at the intersection of Church Street and present-day Park Place. Robert R. Livingston, John Jay, Gouverneur Morris, and Alexander Hamilton were among the Founding Fathers who attended the college.

Politics

On July 11, 1804, Alexander Hamilton was mortally wounded in a duel with the vice president of the United States, Aaron Burr. The duel was the final act of an "affair of honor," a highly ritualized war of words between two men looking to protect their personal and political reputations. When Hamilton died the next day, he left a widow in debt and a city in mourning, and Burr found himself disgraced.

This tragic event encapsulated the partisan, petty, and frequently scandal-ridden politics of Federalist-era New York. Alongside high-minded debate over national public policy, political leaders dealt in innuendo and personal attacks, using the press to discredit their opponents. As men jockeyed to define their positions within the new nation, women worked to balance their traditional responsibilities with new opportunities—through education and acceptable public roles, such as those for private charities that focused on children and the poor.

By considering this tumultuous social context, the following works help reveal the contradictions behind the partisan factionalism that characterized the individuals who at once fought to build the country and promote their own advancement.

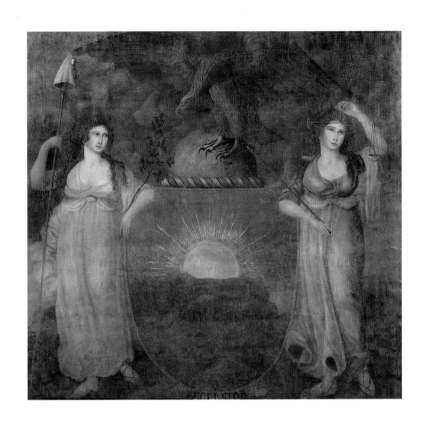

Unidentified artist
Excelsior, ca. 1775–1800
Oil on linen | X.731

In 1777, when New York shed its status as a British colony, the new state required an emblem under which to conduct official business. The New York Council of Safety assigned the task of preparing a "proper device for the great seal of this State" to John Sloss Hobart, Lewis Morris, and John Jay. A second committee, consisting of Governor George Clinton and Chancellor Robert R. Livingston, continued the task. By 1778, the complete arms and seal of the State of New York were finalized and formally adopted. The symbolic set of images evoked classic republican virtues of Liberty and Justice, European heraldry, and the dawning potential of the New World, expressed in the state motto "Excelsior," or "Ever Higher."

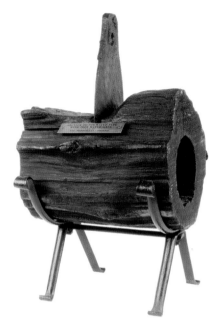
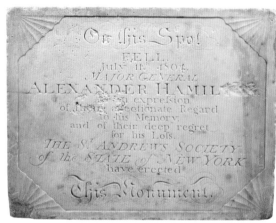

Unidentified maker

Section of wooden water pipe used in New York City, 1799–1850

Wood | Gift of J. W. Rutherford, X.47

This piece of wooden pipe was excavated in 1916 at the corner of Broad and Pearl Streets, in front of Fraunces Tavern, in lower Manhattan. It is likely part of the infrastructure laid by the Manhattan Company, which was founded by Aaron Burr in 1799, ostensibly to provide water for the city. However, a clause in the company's charter allowed Burr to form a bank, creating a rival to Alexander Hamilton's Bank of New York. The company did an inadequate job of supplying potable water, and many people purchased water from peddlers instead.

Unidentified artist

Cenotaph marking the site where Alexander Hamilton was wounded, ca. 1805

Marble | Gift of the heirs of Archibald Gracie King, 1900.5

This inscribed slab is all that remains of a fourteen-foot-high monument that consisted of a four-foot square base, topped with an obelisk and a flaming urn. An engraving by Caleb Ward, published around 1830 and entitled *View of the Spot where General Hamilton Fell at Weehawk*, shows the monument as it was installed in Weehawken, New Jersey, at the site where Hamilton was mortally wounded in his duel with Aaron Burr in 1804. The Saint Andrew's Society, of which Hamilton was a member, commissioned the monument shortly after his death, but by 1821 vandals and souvenir-seekers had broken it apart. This slab was recovered from a junk shop in 1835.

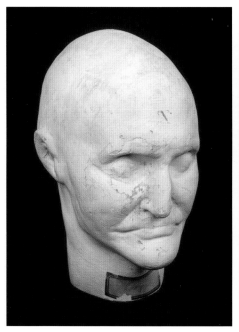 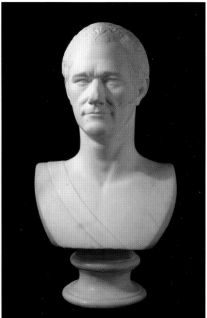

Unidentified maker for Fowler & Wells
Death mask of Aaron Burr (1756–1836), 1836
Painted plaster | Museum purchase, 1946.348

Immediately after Aaron Burr's death in 1836, a mysterious man entered his chamber and made a plaster cast of his head. The maker of this death mask was employed by Orson and Lorenzo Fowler, popular phrenologists who claimed to be able to read a person's character from their facial and cranial features. The Fowlers put Burr's death mask on display in their Phrenological Cabinet as an example of "secretiveness" and "destructiveness."

Giuseppe Ceracchi (1751–1801)
Alexander Hamilton (1755–1804), ca. 1793
Marble | Gift of Mr. James Gore King, 1928.18

The Italian artist Giuseppe Ceracchi modeled Alexander Hamilton at the height of his influence, when he served as the first United States Secretary of the Treasury. After Hamilton's untimely death, Ceracchi's bust was widely reproduced and used as a model for commemorative portraits.

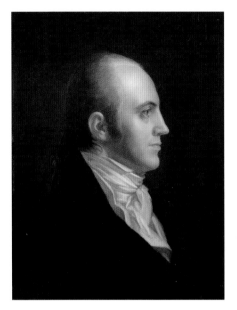 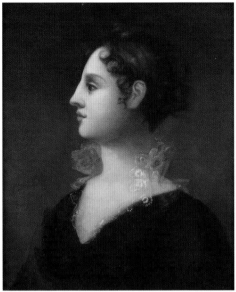

John Vanderlyn (1775–1852)
Aaron Burr (1756–1836), 1802
Oil on canvas | Gift of Dr. John E. Stillwell, 1931.58

In 1795, Aaron Burr wrote to his friend Peter Van Gaasbeek that he was "infinitely flattered by an opportunity of rescuing genius from obscurity." The genius in question was the promising young painter John Vanderlyn, whose studies in Paris were generously sponsored by Burr. Vanderlyn reciprocated this generosity by assisting Burr when he fled to France in the wake of his duel with Hamilton.

John Vanderlyn (1775–1852)
Theodosia Burr (Mrs. Joseph Alston, 1783–1813), 1802
Oil on canvas | Gift of Dr. John E. Stillwell, 1931.60

John Vanderlyn painted Burr's daughter Theodosia, a celebrated beauty, several times. Burr believed that women should be able to participate in politics and even educated his daughter according to the strictures of early women's rights advocate Mary Wollstonecraft. This portrait was executed shortly after her marriage to Joseph Alston, then a congressman from South Carolina, in 1801.

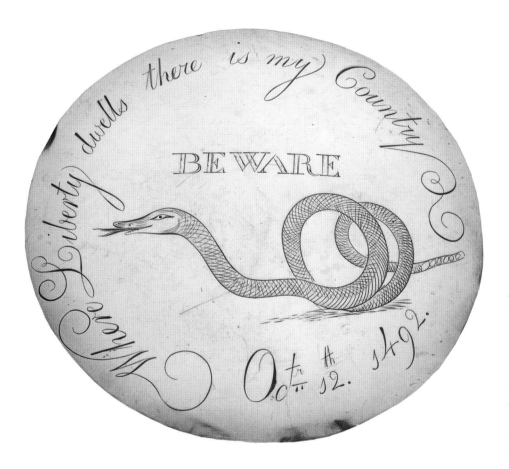

Unidentified American maker

Tammany Society badge, 1790–1815

Silver | Gift of Robert G. Goelet, 1982.106

The Tammany Society, named after the legendary Lenni-Lenape Chief Tamanend, celebrated its roots on the American continent with titles, imagery, and rituals appropriated from American Indian tribal customs. As the first "Sagamore," or master of ceremonies, John Pintard inspected and approved membership badges such as this one. The rattlesnake motif and the motto "Beware" signified that the Sons of Tammany would avenge any insult. Pintard—better known as the founder of the New-York Historical Society—hoped that the Tammany Society would eschew partisan politics, but it soon became known as a populist organization, with Aaron Burr as one of its most prominent members.

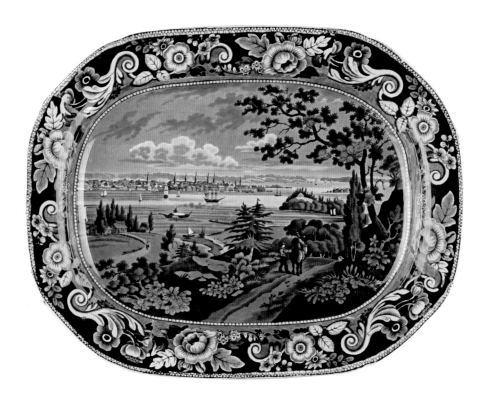

Andrew Stevenson (active ca. 1816–1830), after William Guy Wall (1792–after 1864)
Platter, "New York from Weehawken, New Jersey," 1820–29

Transfer-printed earthenware | Gift of Dr. Arthur H. Merritt, 1961.244

The pastoral view of Weehawken, New Jersey, and New York, across the river, on this platter is based on a print that was made after a painting by William Guy Wall. Although produced in England, the platter depicts the setting for a major event in American history: the duel between Alexander Hamilton and Aaron Burr.

Unidentified maker
Mourning ring, 1805

Gold, hair | Gift of Mr. B. Pendleton Rogers, 1961.5a,b

During the eighteenth century, rings and other mourning jewelry came to incorporate locks of hair, traditional tokens of remembrance and affection. In 1804, as Alexander Hamilton lay on his deathbed, his grieving wife Eliza clipped a lock of hair from his head. Braided and set into this mourning ring, she later presented it to Nathaniel Pendleton, one of Hamilton's closest friends, his second in the deadly duel with Aaron Burr, and the executor of his will. The practice of presenting rings to friends of the deceased was well established in America by the time of Hamilton's death.

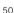

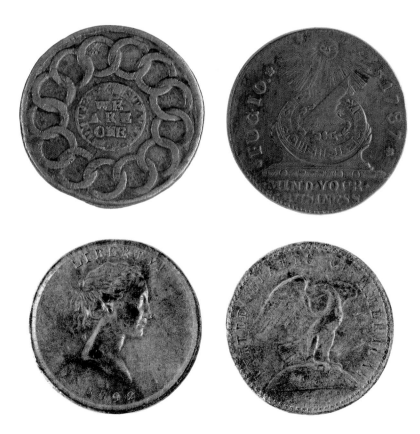

Abel Buell, diemaker (1742–1825), and James Jarvis, minter (active 1786–ca. 1790)
Fugio cent, 1787
Copper | INV.13867c, INV.13869d (obverse and reverse)

The first copper coins ever minted by the United States were named after the Latin inscription that appears on their obverse, *fugio*, which, coupled with the sundial motif and the words "Mind your business," loosely translates to "Time flies, so attend to your business." Fugio cents were minted in 1787, the year the Constitution was ratified, and the reverse bears a design of thirteen chain links and the inscription "We Are One," referring to the newly united country. Their minter, James Jarvis, bribed officials to win the federal contract for their production. However, not only did his employees use the copper advanced to him to mint coins for Connecticut instead, but Jarvis also was unable to procure the copper he was obliged to provide for the project. Jarvis only delivered four tons of coins and fled his debt of $10,842.24. The Fugio cents that he did produce were underweight and were never widely circulated.

Joseph Wright (1756–1793)
Pattern quarter, 1792
Pewter | INV. 13862a, INV. 13862b (obverse and reverse)

This quarter, one of only five in existence, was made during a trial strike in 1792 from a die engraved by Joseph Wright. The die broke in the process and no quarters were ever minted from the pattern. The coin features a bust of Liberty on the obverse, and an eagle atop a half-globe on the reverse.

Nathaniel Pendleton (1756–1821)

"First Statement of the Regulations for the Duel, July 4, 1804"

Nathaniel Pendleton Papers | Bequest of John Shillito Rogers, 1941

Nathaniel Pendleton, a friend of Hamilton's as well as a lawyer and the executor of his estate, helped negotiate the terms of the Hamilton-Burr duel. As Hamilton's representative, or "second," Pendleton stipulated the distance between the parties (ten yards), the weapons (pistols, no longer than eleven inches in the barrel), and who should speak the fateful words, "one, two, three, fire." That role fell by lot to Pendleton. On July 11, 1804, he placed Burr and Hamilton at their stations, stated the rules, and gave the signal. The pistols discharged in close succession. Burr's bullet lodged near Hamilton's liver, while Hamilton's own bullet allegedly hit the branch of a nearby cedar tree.

David Hosack (1769–1835)

Receipt and Bill to the Estate of Alexander Hamilton, August 8, 1805

Nathaniel Pendleton Papers | Bequest of John Shillito Rogers, 1941

Dr. David Hosack sent this bill to Nathaniel Pendleton, Hamilton's executor, after treating Hamilton's injuries from the duel. Despite Hosack's efforts, Hamilton died the next day.

Unidentified artist

Congressional Pugilists, 1798

Engraving | Gift of John B. Murray, 1862

During the 1790s, America's leaders quarreled bitterly, animated by opposing political philosophies, economic interests, and personal animosity. This 1798 political cartoon, depicting a fight between Connecticut Federalist Roger Griswold and Vermont Democratic-Republican Matthew Lyon on the floor of Congress, captures the contentiousness that pervaded 1790s politics. Supposedly, the two quarreled over personal insults, not political issues; Lyon, in fact, spat at Griswold.

Civilization

In 1804, a group of prominent citizens including John Pintard, DeWitt Clinton, and David Hosack founded the New-York Historical Society to "collect and preserve whatever may relate to the natural, civil, or ecclesiastical History of the United States in general and of this State in particular." During a time when state identities still superseded a national one, the founders' vision of a uniquely American narrative was ahead of its time.

The Historical Society was just one of hundreds of voluntary organizations active in New York during the late Federalist era. Prominent and ordinary citizens alike participated in a flourishing civic culture of political and fraternal clubs, botanical and literary societies, and religious and benevolent associations. Their members would create cultural treasures, such as *The Legend of Sleepy Hollow*, and spearhead monumental public works projects like New York's street grid and the Erie Canal. These diverse interests propelled the city to become the leading metropolis in the United States.

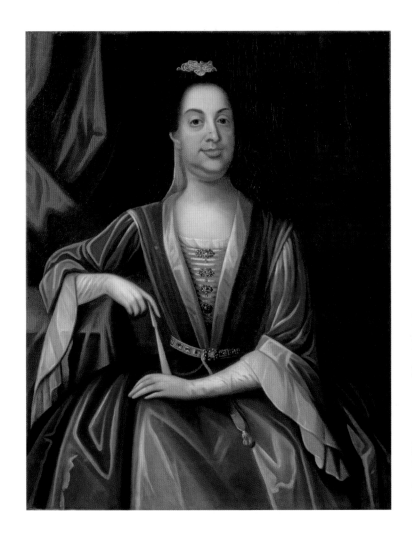

Unidentified artist
Unidentified Woman, ca. 1700–25

Oil on canvas | Museum purchase, 1952.80

The political enemies of Edward Hyde, Viscount Cornbury (Royal Governor of New York from 1702 to 1708) slandered him as an incompetent "half-wit" who often dressed in women's clothing. However, that false rumor was not attached to this painting until around 1796, long after Cornbury's death, during a time when Americans were rejecting their British roots. By 1867, when the South Kensington Museum in London displayed the portrait, a label identifying Cornbury as the sitter had been attached. *The New-York Daily Tribune* then carried the sensational story of the cross-dressing governor's portrait back to America. It endured for over a century, making this otherwise anonymous painting of an eighteenth-century woman one of the most controversial pieces in the collection of the New-York Historical Society.

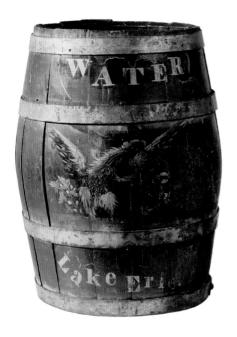
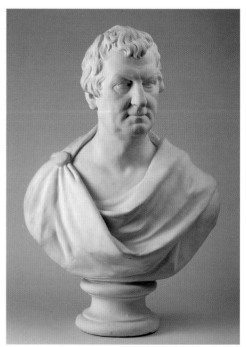

Unidentified American maker
Keg from Erie Canal celebration, ca. 1825
Wood, metal, paint | X.48

This keg, decorated with an eagle and the words "Water" and "Lake Erie," was used by DeWitt Clinton in the ceremonial "wedding of the waters," commemorating the completion of the Erie Canal. The mixing of the waters of Lake Erie and the Atlantic Ocean was the finale to a ten-day series of celebrations that took place along the length of the canal, for which Clinton had been an instrumental advocate.

William John Coffee (1774–1846)
DeWitt Clinton (1769–1828), 1817
Painted plaster | Gift of John Pintard, 1818.2

DeWitt Clinton, US senator from New York (1802–3), mayor of New York City (1803–7), and the sixth governor of New York (1817–22, 1825–28), was the driving force behind the construction of the Erie Canal. He wrote in his diary that he sat for William Coffee several times while this portrait bust was being made. Later, Asher B. Durand used the bust as the model for an engraving of Clinton he made for David Hosack's *Memoir of DeWitt Clinton.*

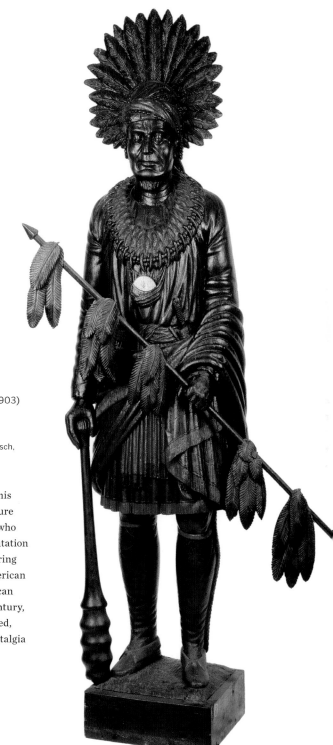

Julius Theodore Melchers (1830–1903)
Sauk Indian Chief Keokuk
(1783–1848), ca. 1870
Painted wood | Gift of Carl Otto von Kienbusch,
1956.86

Julius Melchers, a Prussian-born
sculptor and woodcarver, created this
finely detailed tobacco store sculpture
of the Sauk and Fox Chief Keokuk, who
advocated negotiation over confrontation
with encroaching white settlers during
his lifetime. Stylized images of American
Indians had symbolized the American
continent since the seventeenth century,
but by the time this figure was carved,
they also represented romantic nostalgia
for the vanishing Western frontier.

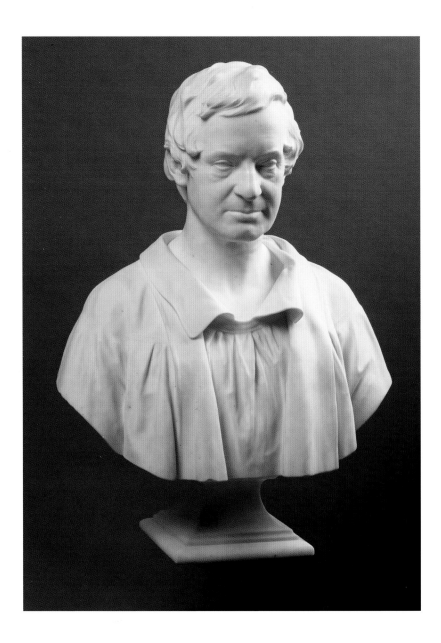

Erastus Dow Palmer (1817–1904)
Washington Irving (1783–1859), 1865
Marble | Gift of Mrs. Anna T. E. Kirtland, as a memorial to Mr. Jared T. Kirtland, 1865.4

One of America's earliest popular fiction writers, Washington Irving pioneered the use of satire in the United States. As "Diedrich Knickerbocker," Irving wrote *A History of New-York*, blending history and satire in a lively review of the city's Dutch origins, and dedicated the book to the New-York Historical Society. He launched his professional writing career as a pro–Aaron Burr journalist and also was an active participant in New York's vibrant club life.

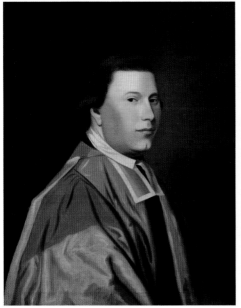 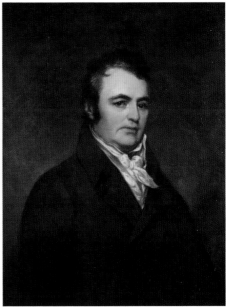

S. B. Hutchings, after John Singleton Copley (1738–1815)
Myles Cooper, D.D. (1737–1785), ca. 1820
Oil on canvas | Gift of Nicholas William Stuyvesant, 1820.1

This portrait of King's College president Myles Cooper is a nineteenth-century copy
of one executed in Boston by J. S. Copley a few years after Cooper's arrival in America
to assume the presidency. Since the college had close ties to Britain, it is fitting that
its president was ardently loyal to the monarchy. When Cooper distributed Loyalist
pamphlets to students in 1775, the Sons of Liberty, an often-radical revolutionary
organization, descended on campus in protest. Student Alexander Hamilton, a patriot
but no supporter of an angry mob, placated the armed crowd, giving Cooper enough time
to escape. Cooper later sailed to England, never to return to New York. King's College
under Cooper exemplified the conservative state of elite education in eighteenth-
century America—closely tied to church, crown, and classics. In contrast, the dawn
of the nineteenth century saw a growing interest in American history and literature,
exemplified by the founding of the New-York Historical Society.

John Trumbull (1756–1843)
John Pintard (1759–1844), 1817
Oil on canvas | Commissioned from the artist by the New-York Historical Society, 1817.3

John Trumbull, one of the foremost artists of his day, was known for his portraits of the
heroes of the Continental Army, in which he served as a colonel. In 1817, Trumbull was
newly elected president of the American Academy of Fine Arts in New York City, and was
selected by the New-York Historical Society to commemorate its founder, John Pintard.

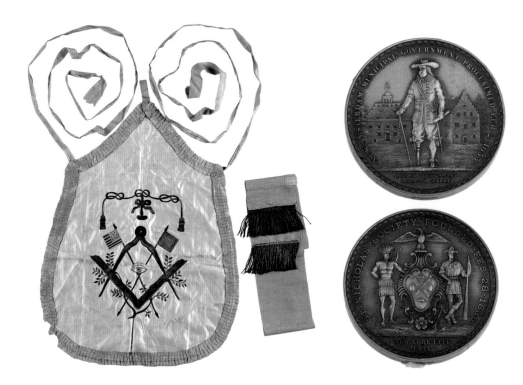

Unidentified maker

Masonic apron, 1770–1800

Silk, metal | Gift of Goodhue Livingston Jr., 1951.523a

Members of the Grand Masonic Lodge of New York, established in 1782, wore aprons
such as these when participating in the rituals of Freemasonry. Some of the country's
most influential citizens—George Washington, Benjamin Franklin, DeWitt Clinton,
and many others—were members. As American Masonic regalia was not standardized
until late in the nineteenth century, American aprons are characterized by a high
degree of individuality. This apron, owned by Chancellor Robert R. Livingston,
is strikingly similar to an apron supposedly presented to George Washington by the
Marquis de Lafayette.

Tiffany & Co.

Saint Nicholas Society Medal, 1903

Bronze | 819

This bronze struck medal, commissioned by the hereditary Saint Nicholas Society,
commemorates the 250th anniversary of the granting of municipal government to
New Amsterdam, in 1653, under Director-General Peter Stuyvesant. The society's
seal, featuring an American Indian and a European settler flanking a shield topped by an
eagle, is directly modeled on an early version of the New York City seal.

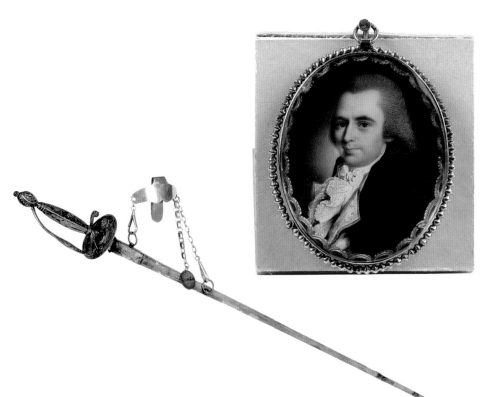

Unidentified maker
Small sword and scabbard, 1780–90

Steel, silver, gilding, enamel; wood, fish skin, metal | Gift of Mrs. Louis T. Hoyt,
in memory of Richard Montgomery Pell, 1928.51a–d

The roundel attached to this sword identifies it as the property of prominent New York
politician and governor of New York, DeWitt Clinton. Though Clinton served as an
officer in a volunteer artillery company, small swords such as this one were standard
civilian arms as well. This elegant and elaborately decorated sword may have been
imported from France, as were many luxury goods in the eighteenth century.

John Ramage (ca. 1748–1802)
John Pintard (1759–1844), 1787

Watercolor on ivory, with hairwork on reverse | Gift of George Hancock Servoss, 1906.2

Miniatures were commissioned for a variety of reasons, ranging from joyous occasions
like a birth or a marriage, to mournful ones like a death. Frequently worn on the body
in the form of pendants and brooches, portrait miniatures commemorated personal
relationships. John Pintard criticized this miniature painted by John Ramage, writing
to his daughter Eliza that the likeness was "too much of an Adonis for me to recollect
any resemblance."

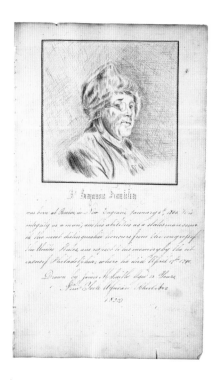

James McCune Smith (1813–1865), after Charles Nicholas Cochin (1715–1790)

Dr. Benjamin Franklin, 1820

New York African Free School Records Volume IV, Studies in Penmanship and Drawing | BV African Free School

The African Free School, founded in 1787 by the New-York Manumission Society, was dedicated to providing young black New Yorkers a thorough education, but often taught respect for ideals that its students could not then fully realize in American society. James McCune Smith created this sketch while a student there. Unable to pursue higher education in the United States because of his race, Smith traveled to Glasgow, where he eventually earned his medical degree. He returned to New York as the first African American doctor in the country's history and opened the first black-owned apothecary shop in the United States, located on West Broadway.

"American Museum & Waxwork," 1793

Broadside | SY1793 no. 35

This advertisement for the American Museum indicates the broad scope of its collection. Visitors to the museum could see a variety of exhibits, including displays of exotic live animals, foreign weapons, life-sized wax figures, and a horn that grew out of a New York woman's head.

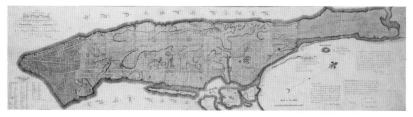

Washington Irving (1783–1859)
A History of New-York, from the beginning of the world to the end of the Dutch dynasty
Dedication page | New York: Inskeep and Bradford, 1812 | F122.2.I83 1812

Irving's *History of New-York* is based on the actual history of the city, but the story is embellished into witty satire. Although many Americans initially bristled at the novel, the book was extremely popular in Europe and became the first American international bestseller. Irving dedicated this book to the New-York Historical Society, an institution he mocked for its self-aggrandizement and epic sense of mission, though he remained a member for several decades.

William E. Bridges
"This map of the city of New York and island of Manhattan as laid out by the Commissioners appointed by the legislature..." [Commissioners' Plan], 1811
Black and color ink with hand-colored wash on paper | Gift of Mr. William Millard Morgan September 27, 1934, NS13 M6.1.4

In 1811, the state legislature approved a plan authored in part by Founding Father Gouverneur Morris that proposed to lay out New York streets according to a grid. Although many prominent New Yorkers, such as Mayor DeWitt Clinton, endorsed the plan, not all were in support. Some, like Clement Clarke Moore, a professor and writer, argued that the proposed grid would destroy Manhattan Island's natural topography and break up the large real estate holdings of landowners. However, Manhattan's growth was inevitable. By the 1830s, even Moore had divided his property, Chelsea, into smaller parcels and begun laying out a carefully ordered suburban community.

This edition © 2012 The New-York Historical Society
Text and illustrations © 2012 The New-York Historical Society

First published in 2012 by
The New-York Historical Society, 170 Central Park West, New York, NY, 10024, USA
www.nyhistory.org

in association with

Scala Publishers Ltd., Northburgh House, 10 Northburgh Street, London EC1V 0AT, UK
www.scalapublishers.com

Distributed in the book trade by

Antique Collectors' Club Limited, 6 West 18th Street, Suite 4B, New York, NY 10011, USA

Printed and bound in China
10 9 8 7 6 5 4 3 2 1

ISBN 978-1-85759-776-9

For the New-York Historical Society:
Historian for Special Projects: Valerie Paley
Assistant Historians for Special Projects: Julie Golia, Lilly Tuttle, and Megan K. Doherty
Editorial Staff: Jeanne Gardner, Chandler Jenrette, Andrew Kryzak, and Marlena Slowik
Photography: Michael and Barry Gross

For Scala Publishers:
Design: Benjamin Shaykin
Project Manager: Eugenia Bell

Front cover: Francis Guy, *Tontine Coffee House, New York City*, ca. 1797; back cover (top): Andrew Stevenson, after William Guy Wall, Platter, "New York from Weehawken, New Jersey," 1820–29 (detail); back cover (bottom): Unidentified American maker, Tammany Society badge, 1790–1815; p. 2: Unidentified maker, Milestone, ca. 1802; p. 5: Barnardus Swartwout, Orderly Book, 2nd New York Regiment, 1781